Samantha Friedman Cristina Pieropan

What Degas Saw

With reproductions of works by Edgar Degas

The Museum of Modern Art, New York

The world was changing.
Paris was alive.

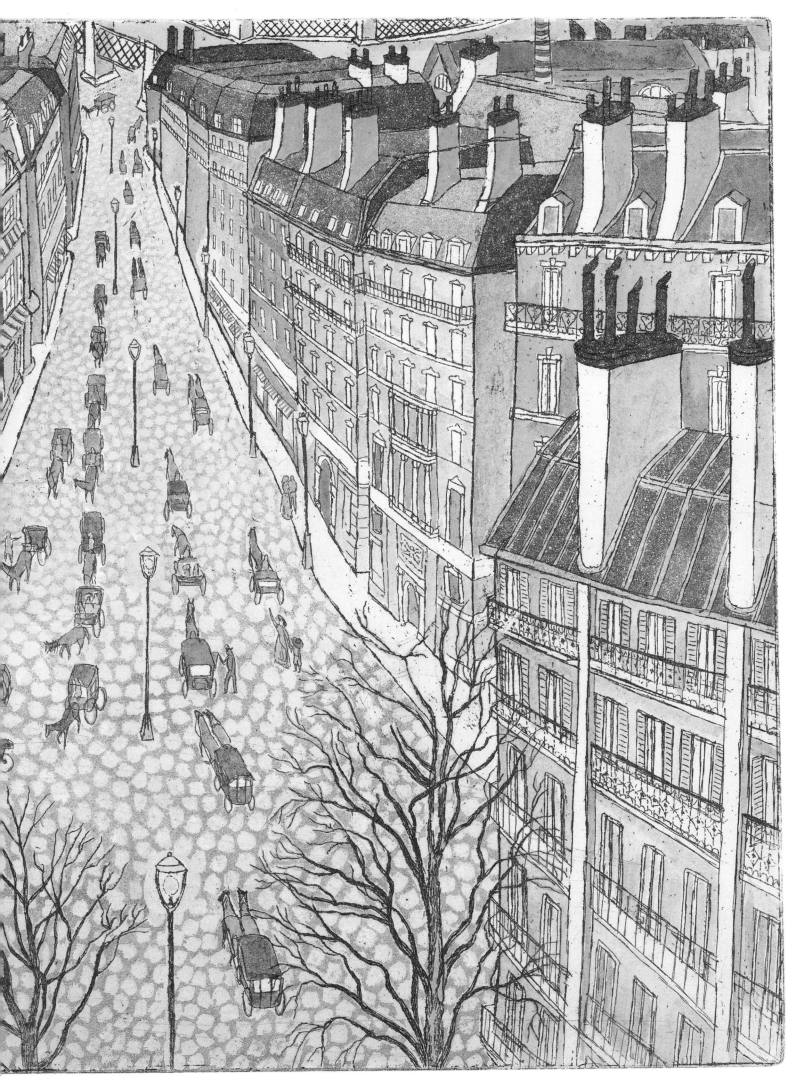

From his studio window on rue Victor Massé, the artist Edgar Degas could see pedestrians strolling on wide, new boulevards . . . smoke rising from new factories . . . grand new buildings of iron and glass.

Degas used to make pictures about the past. He drew figures draped in cloth, and he painted scenes from ancient wars.

But what was happening outside his window was much more exciting. He wanted to find a way to capture the beauty of the passing moment.

Degas's favorite way to explore the newly bustling city was to walk—wearing his cape and tapping his cane—or to take the bus.

That way, he thought, "you can watch people.
We are made to look at each other, don't you think?"

From the window of the moving bus, the faces of passersby looked blurry. Modern life, Degas was realizing, was life in motion.

All across busy Paris, he studied the movements of people at work and at play.

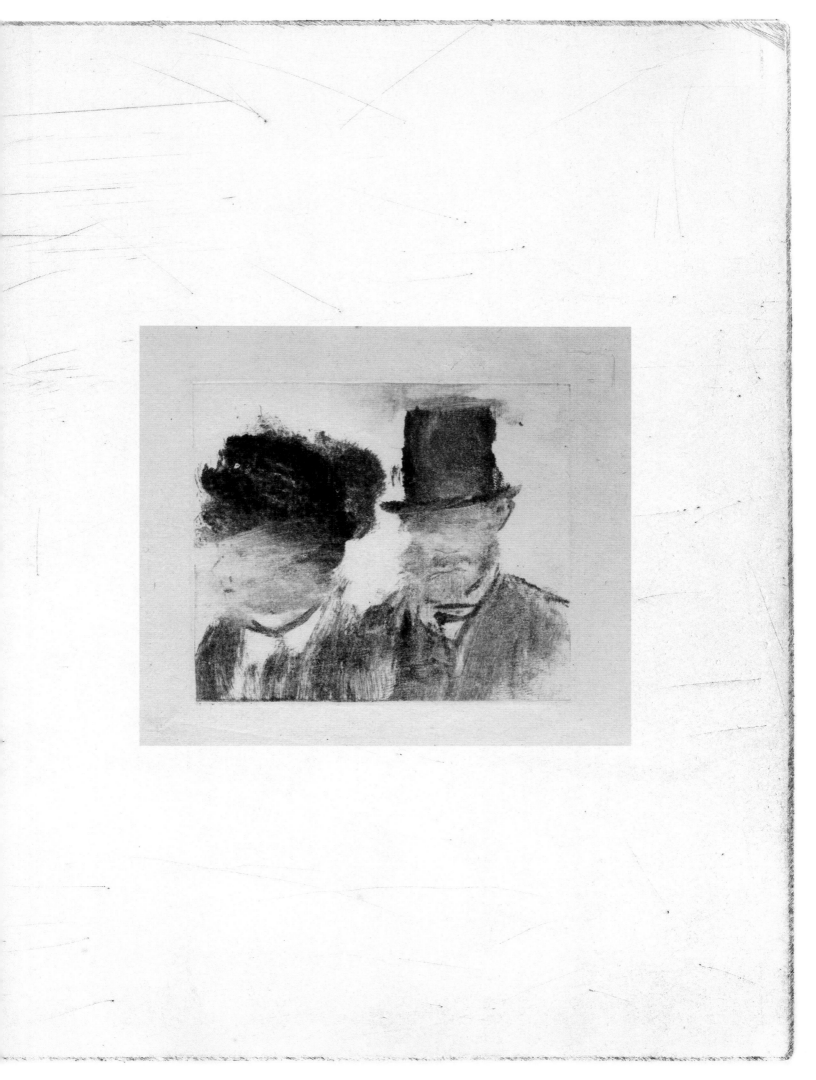

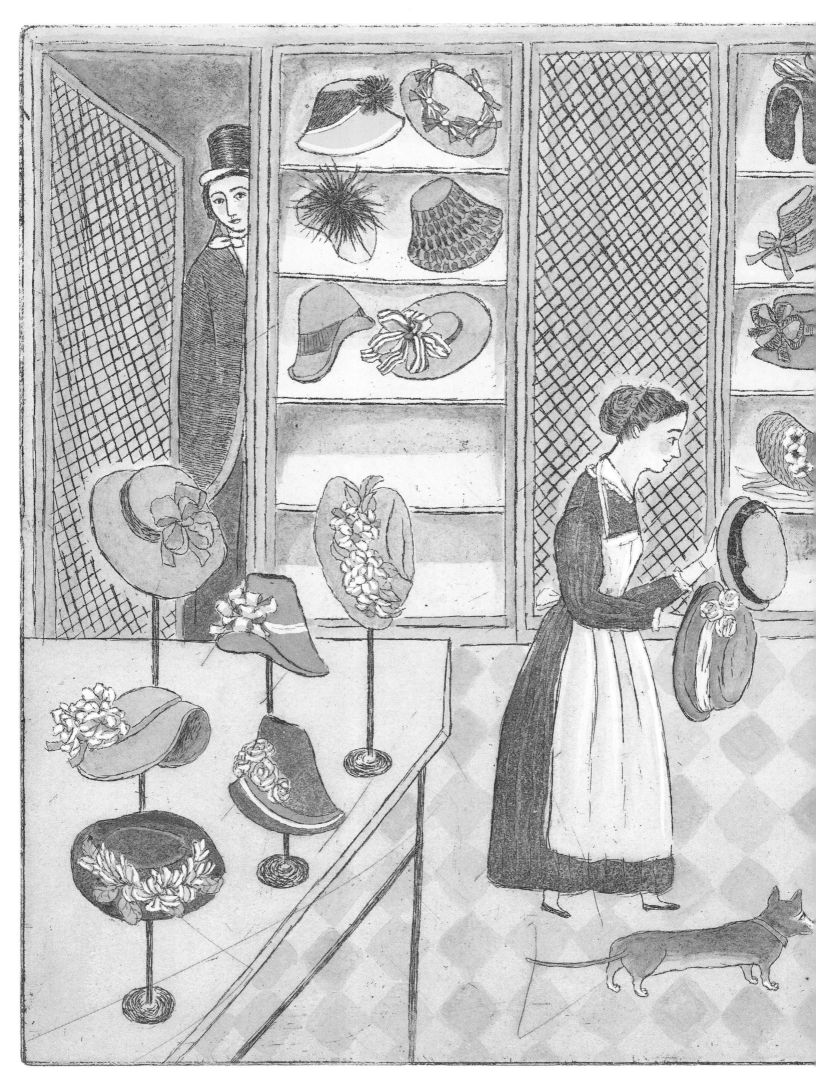

At the milliner's shop, an eager salesgirl juggled several hats for a fashionable lady to try on.

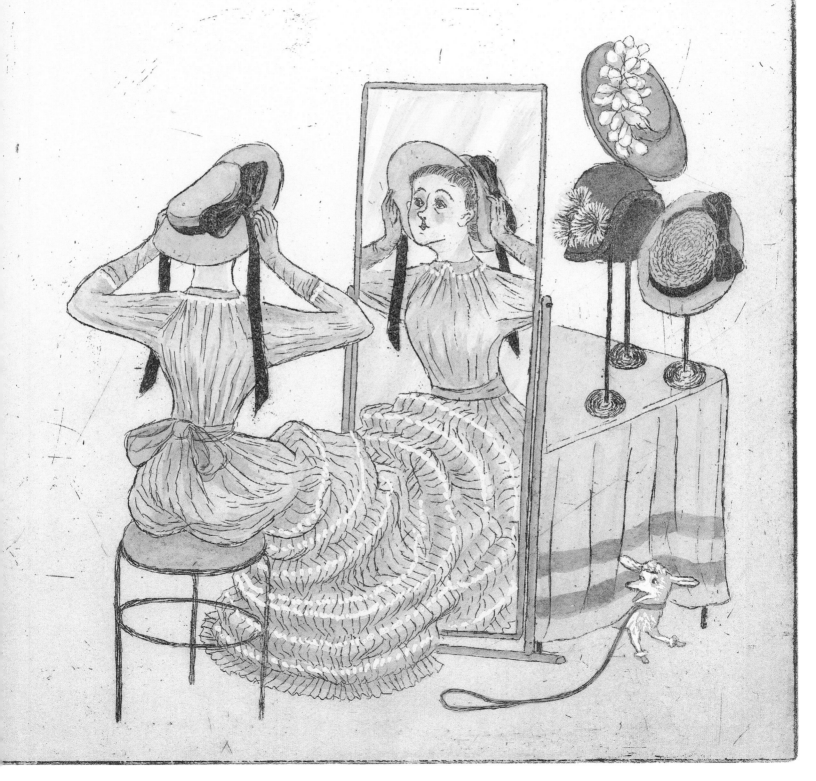

Which one would the customer choose?

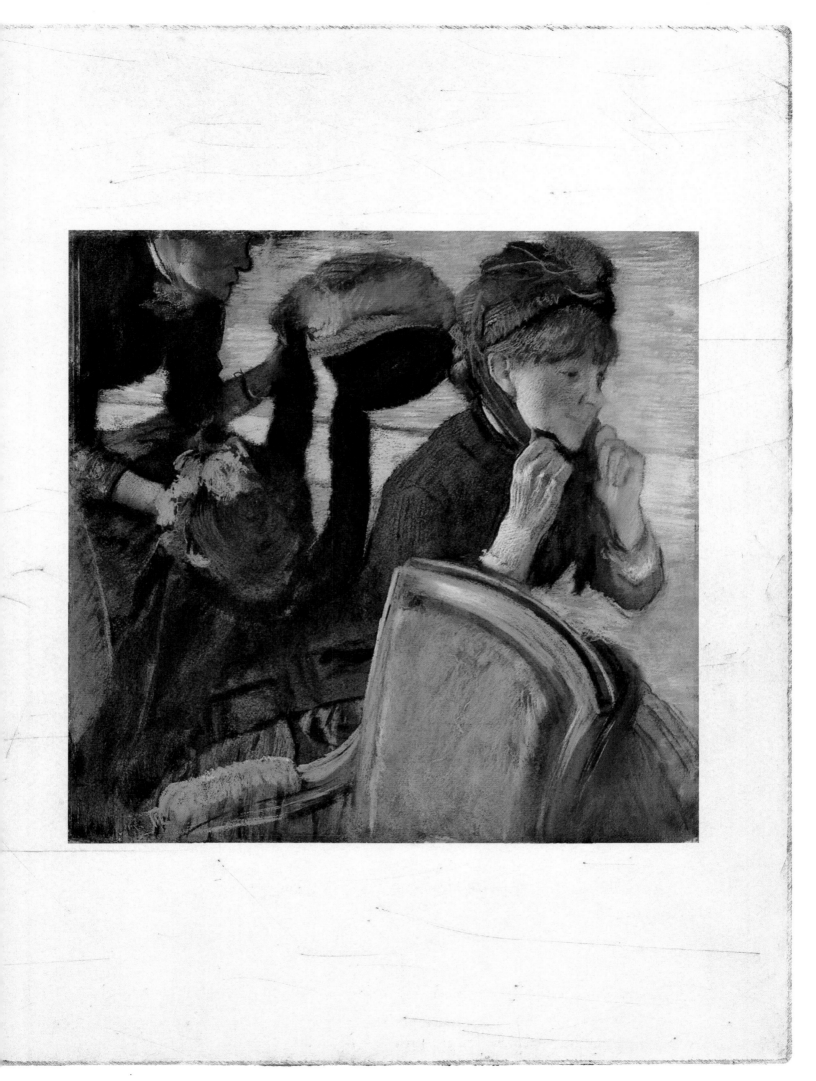

At the laundry, two women were hunched over their irons, pushing and pulling them across freshly cleaned linens.

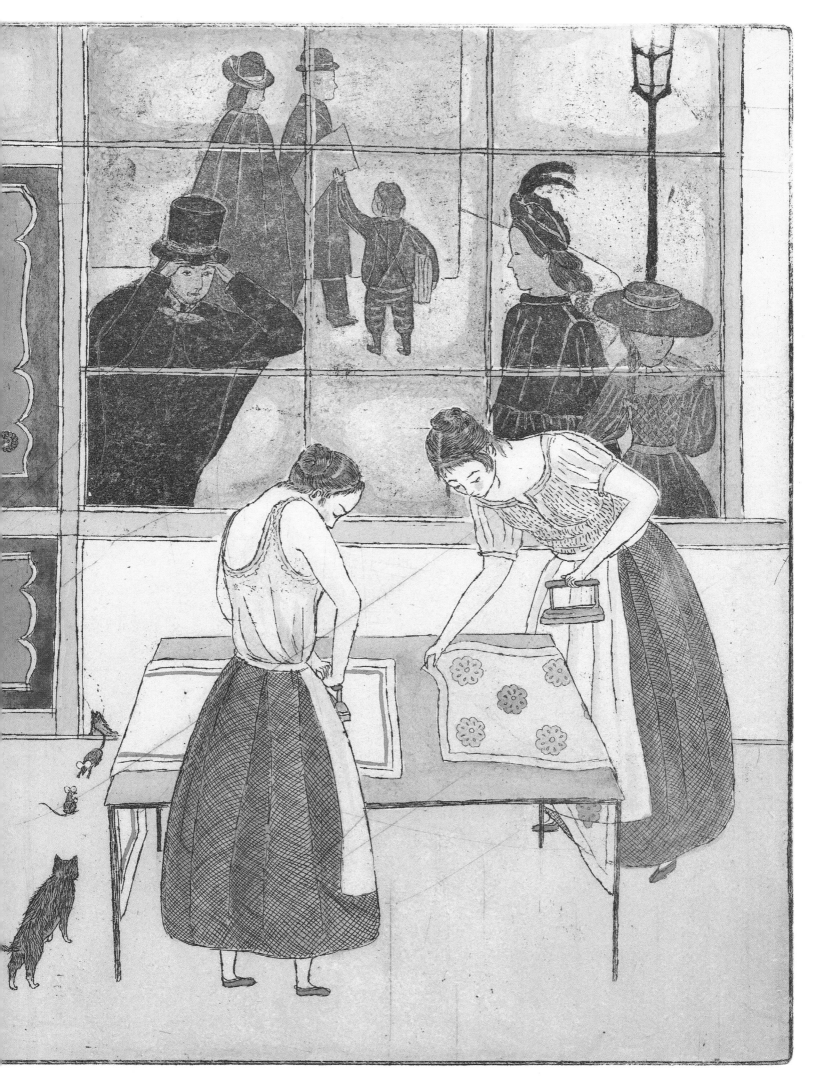

When would their workday be done?

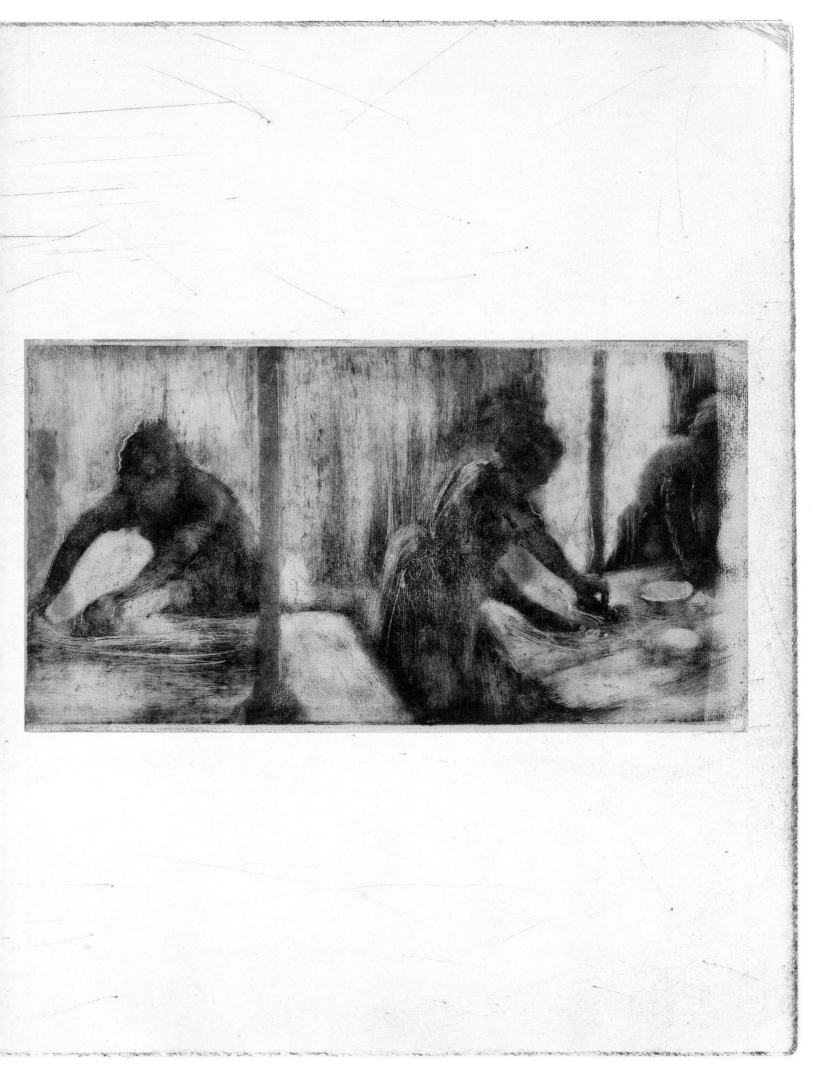

At the racetrack, the horses' muscles flexed beneath their glossy coats. Degas watched them carefully as they ran, but he was just as interested in the well-dressed spectators.

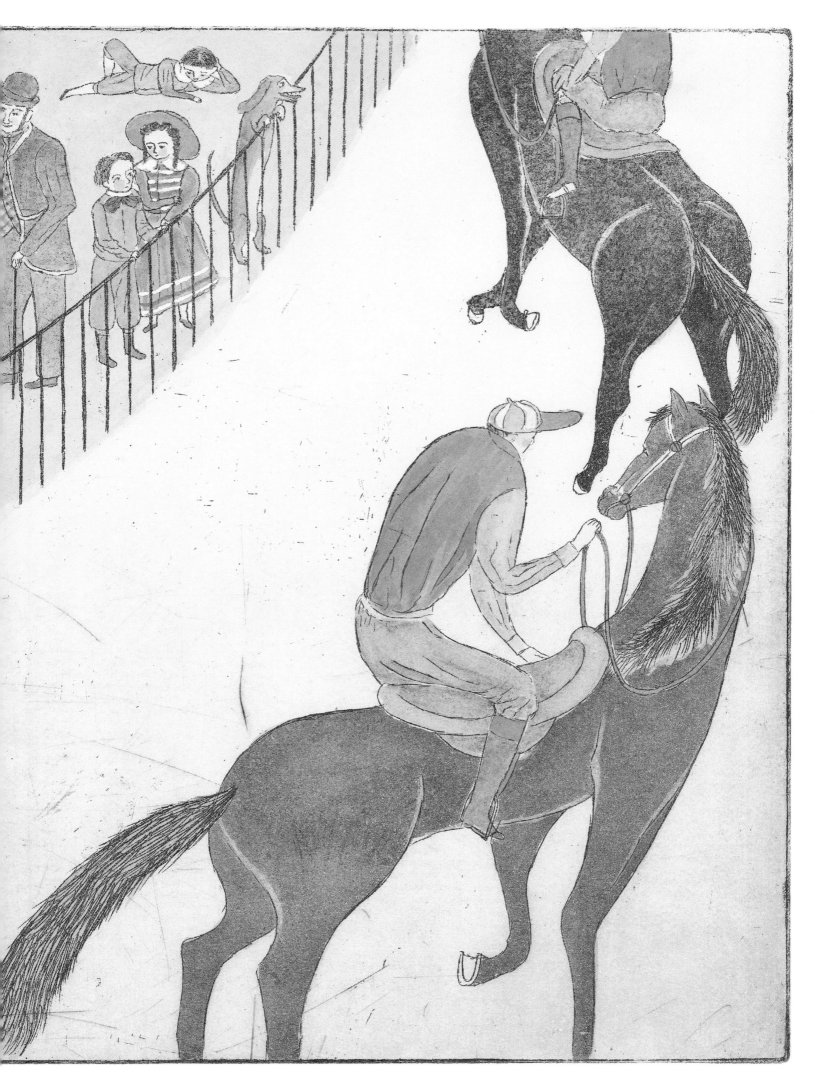

What fresh gossip were they leaning in to whisper?

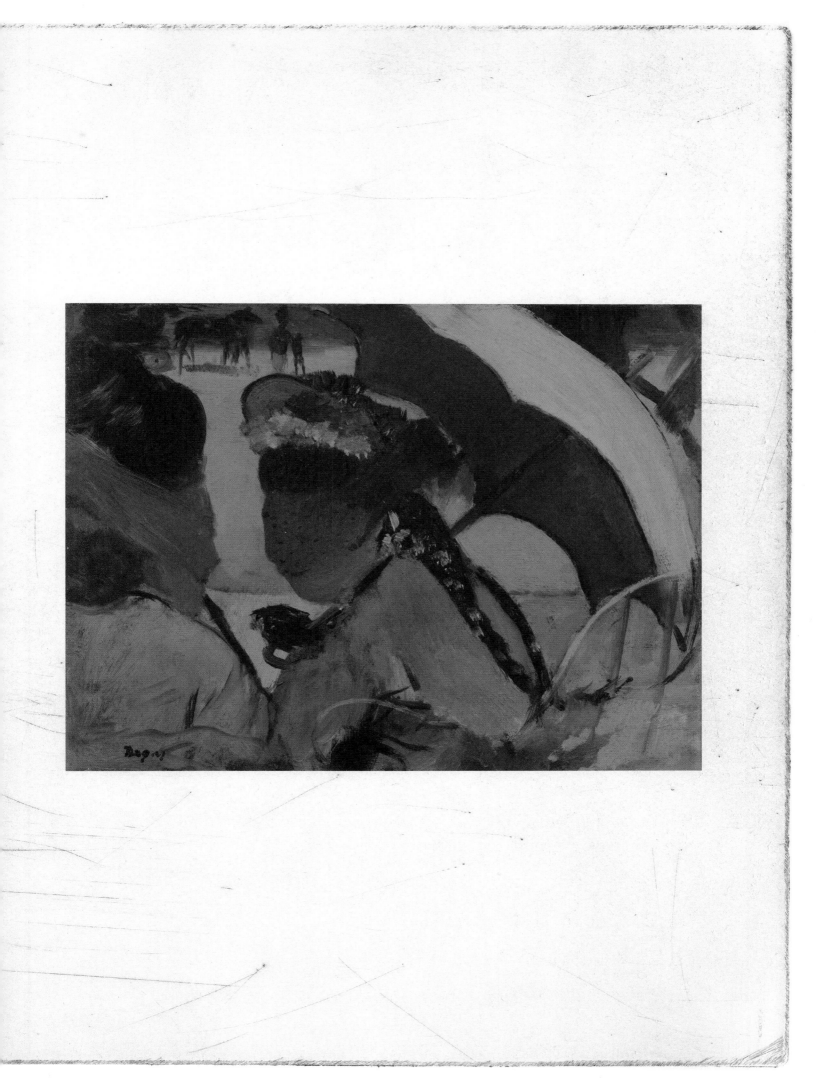

At the Opera House—perhaps Degas's favorite place in all of Paris—dancers performed glorious ballets on the wide wooden stage.

The world outside was in motion, but inside the theater, the artist had to remain even more alert to catch fleeting movements . . .

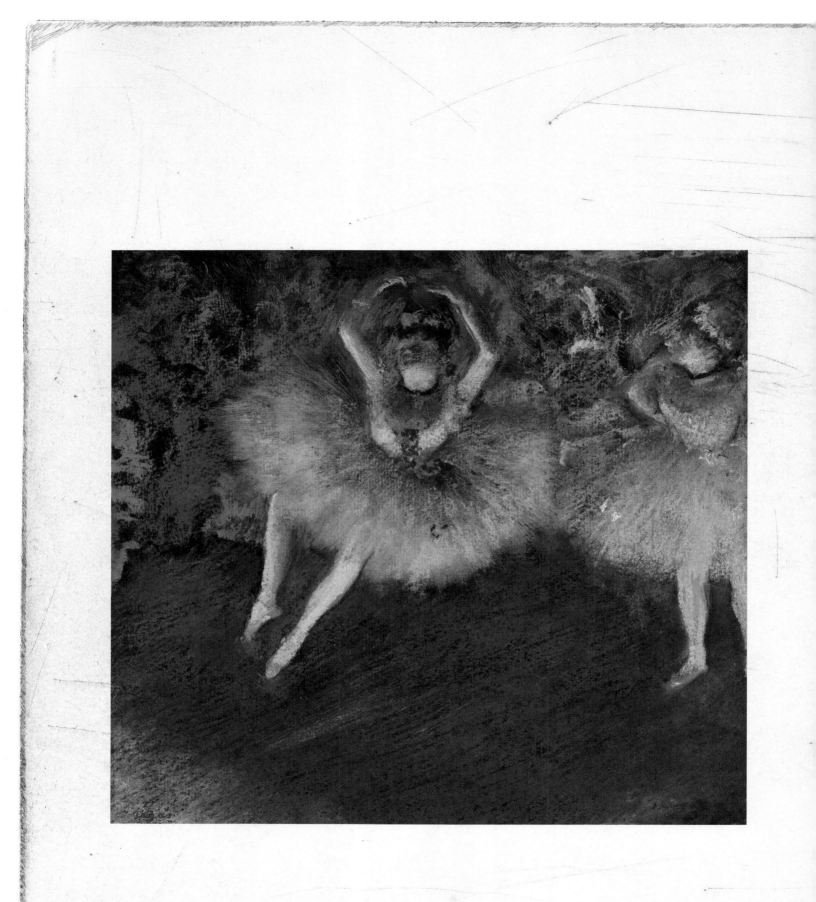

. . . like the moment at the peak of a ballerina's jump . . .

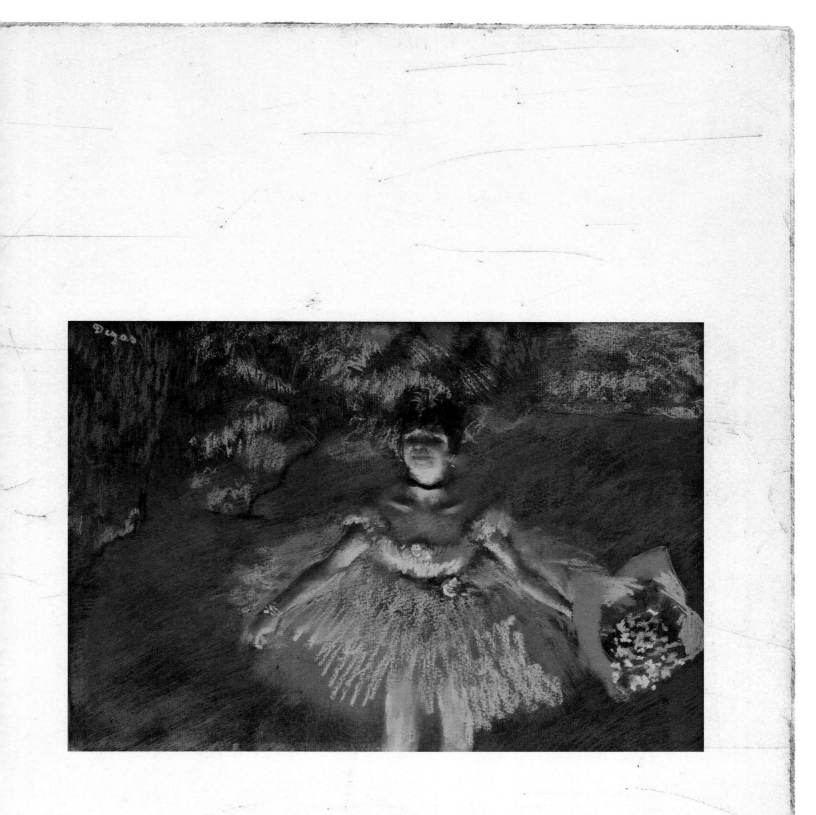

. . . or her light-bathed bow.

A quieter kind of dance continued backstage.

Degas watched ballerinas dreamily stretching
and chatting . . .

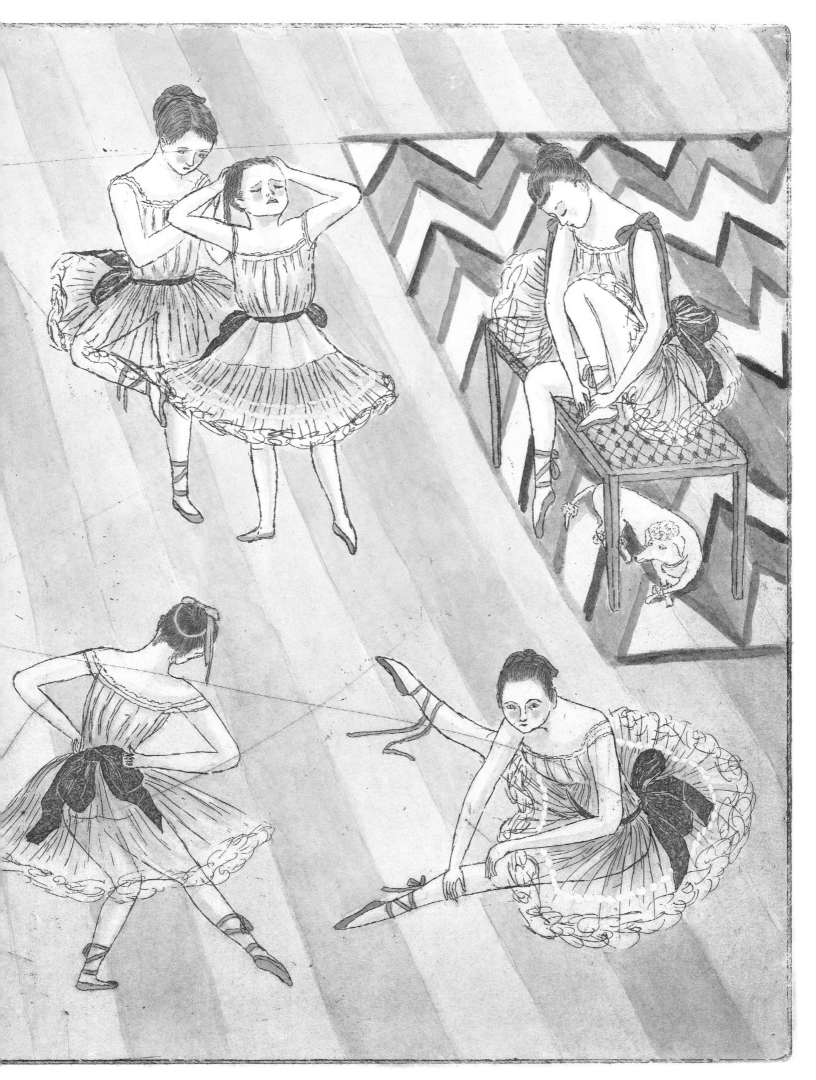

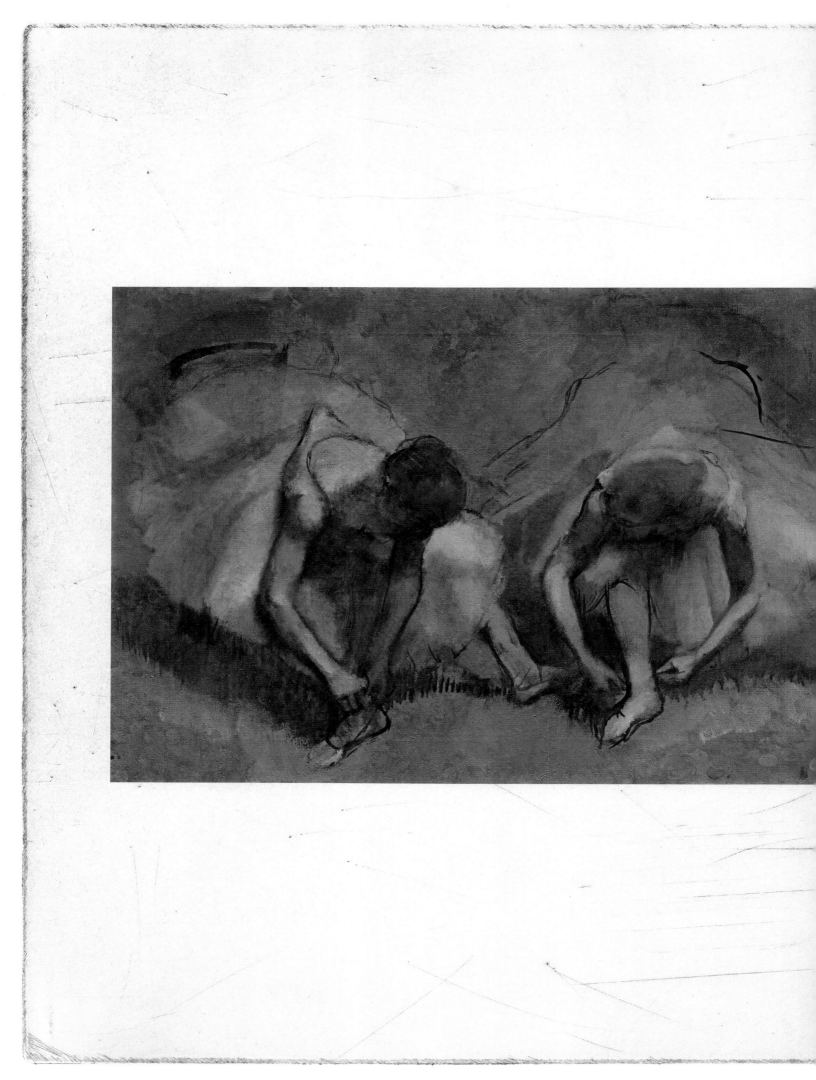

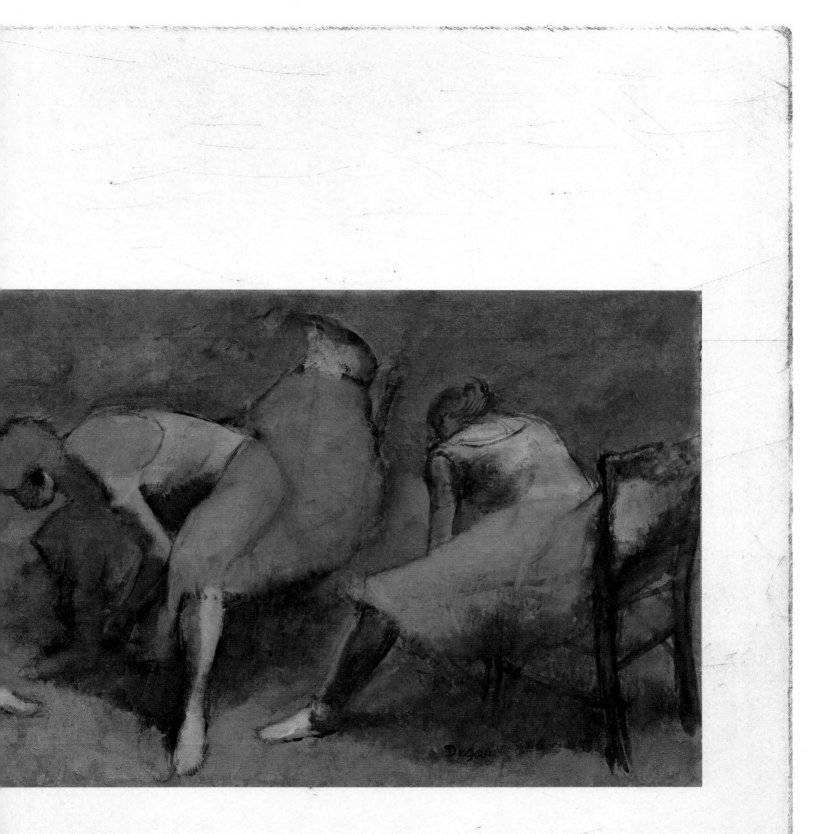

. . . and observed from every possible angle
as another dancer carefully tied the ribbons
of her slippers.

Back in his studio, Degas thought about what he saw, replaying the scenes of the city in his mind.

Soon he would put brush to canvas, or pastel to paper, or ink to plate, and he would try to describe the city's push and pull, its run and jump, its lean and stretch.

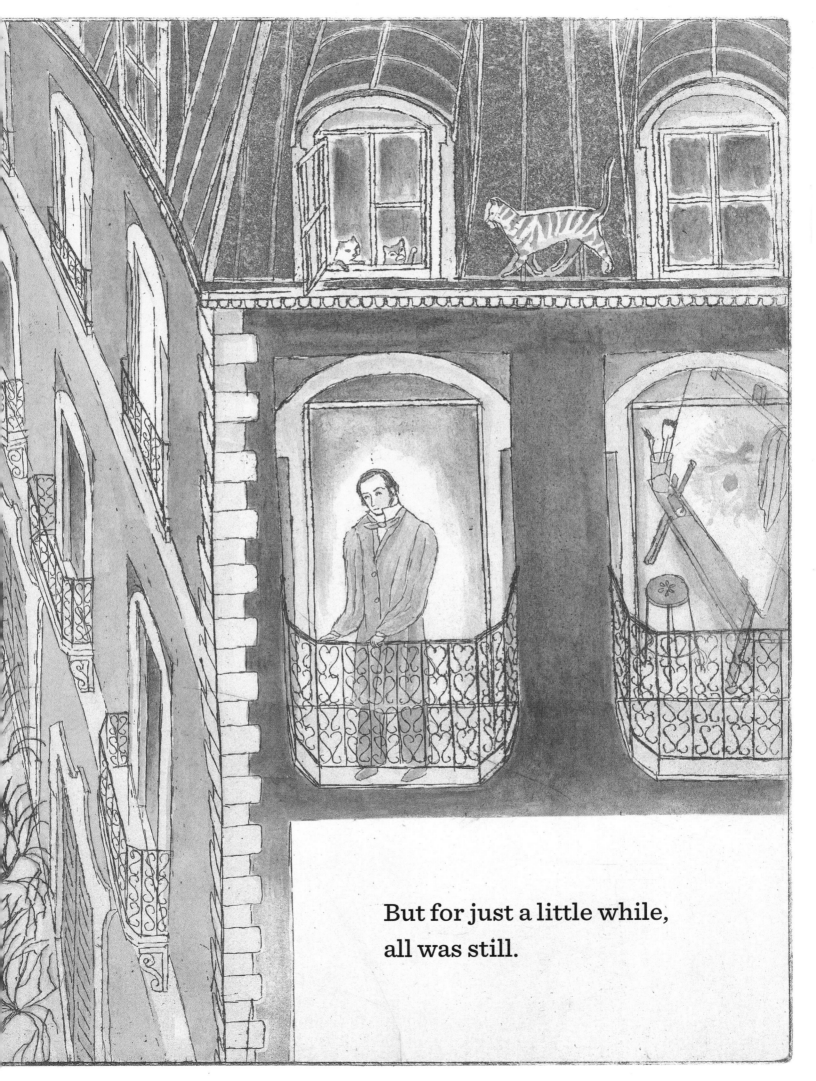

But for just a little while,
all was still.

Produced by the Department of Publications
The Museum of Modern Art, New York

Christopher Hudson, Publisher
Chul R. Kim, Associate Publisher
David Frankel, Editorial Director
Marc Sapir, Production Director

Edited by Chul R. Kim and Emily Hall
Designed by Tsang Seymour
Production by Hannah Kim
Printed and bound by Ofset Yapimevi, Istanbul

With thanks to Cerise Fontaine, Cari Frisch, Jodi Hauptman,
Elizabeth Margulies, Wendy Woon, and Amanda Washburn

This book is typeset in Mrs Eaves and Sentinel.
The paper is 150 gsm Amber Graphic.

Library of Congress Control Number: 2016931554
ISBN: 978-1-63345-004-2

Published by The Museum of Modern Art
11 West 53 Street
New York, New York 10019
www.moma.org

Distributed in the United States and Canada by Abrams
Books for Young Readers, an imprint of ABRAMS, New York

Distributed outside the United States and Canada by
Thames & Hudson Ltd.

Printed in Turkey

Photography Credits

© The Trustees of the British Museum/Art Resource, NY
(*Heads of a Man and a Woman*)

© The Cleveland Museum of Art (*Frieze of Dancers*)

The Museum of Modern Art, New York, Department of
Imaging and Visual Resources (*At the Milliner's*)

Private collections (*Ironing Women, At the Races, Pas battu,
Dancer Onstage with a Bouquet*)

Edgar Degas (1834–1917)

Hilaire-Germain-Edgar Degas—painter, draftsman, printmaker, and sculptor—was born in 1834 in Paris. There, as a young man, he studied at the École des Beaux-Arts, and at the Musée du Louvre he copied the work of Italian Renaissance masters, whose work he studied during a period spent in Italy. He was also influenced by the flowing, arabesque line of the French Neoclassical artist Jean-Auguste-Dominique Ingres. Degas exhibited works in the Paris Salon in the 1860s and later was among the founding members of the Impressionist group, which broke with academic tradition and began, in 1874, to exhibit independently. Degas, however, disliked the term Impressionist and preferred to align himself with the Realists, who based their work on direct observation of the everyday world. In the 1870s he began to depict scenes of life in the modern city, at the racetrack, cabaret, and ballet, among other milieus. These new subjects called for new techniques: in the late 1870s and 1880s Degas began to experiment with the possibilities afforded by the monotype—a unique print, sometimes layered with pastel—and wax sculpture, and in the 1890s he worked in the relatively new medium of photography as well. These explorations across various mediums, all of them suited to repetition and variation, shaped the artist's late work. He died in Paris in 1917.

What Degas Saw features these works:

Heads of a Man and a Woman. c. 1877–80

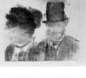

Monotype on paper
Plate: 2 ¹³⁄₁₆ × 3 ³⁄₁₆ in. (7.2 × 8.1 cm)
British Museum, London. Bequeathed by Campbell Dodgson

At the Milliner's. c. 1882

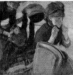

Pastel on paper mounted on board
27 ⅝ × 27 ¾ in. (70.2 × 70.5 cm)
The Museum of Modern Art, New York. Gift of Mrs. David M. Levy

Ironing Women. c. 1877–79

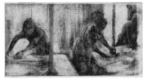

Monotype on paper
Plate: 9 ½ × 17 ½ in. (24.1 × 44.5 cm)
Private collection

At the Races. c. 1876–77

Oil on canvas
7 ½ × 9 ¹¹⁄₁₆ in. (19.1 × 24.6 cm)
Private collection

Pas battu. c. 1879

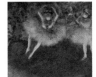

Pastel over monotype on paper
10 ¾ × 11 ⅝ in. (27.3 × 29.5 cm)
Private collection

Dancer Onstage with a Bouquet. c. 1876

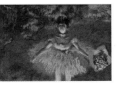

Pastel over monotype on paper
Plate: 10 ⅝ × 14 ⅞ in. (27 x 37.8 cm)
Private collection

Frieze of Dancers. c. 1895

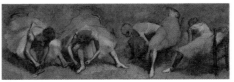

Oil on canvas
27 ⁹⁄₁₆ × 78 ¹⁵⁄₁₆ in. (70 × 200.5 cm)
The Cleveland Museum of Art. Gift of the Hanna Fund